12-22-07

12-22-07

REBECCA BALCHIN graduated from the Kent Institute of Art and Design with a degree in Fine Art in 2001. She went on to train as a teacher and currently enjoys teaching art, photography and life drawing at St John's RC Comprehensive School in Kent.

As a young artist, a natural love of horses helped to hone her drawing abilities. Since then she has revisited this subject, exploring the myth of the horse through installation, photography, painting and sculpture. Her artwork has been shown in several exhibitions in the UK.

Rebecca also works freelance, producing highly sensitive and accurate equine portraits to commission. This is her second book for Search Press following the successful *Angel and Fairy Designs.*

The Search Press Fantasy Art Series

Painting Dragons in Watercolour
Paul Bryn Davies
1 84448 151 4
978-1-84448-151-4

Painting Angels in Watercolour
Elaine Hamer
1 84448 147 6
978-1-84448-147-7

Painting Fairies in Watercolour
Paul Bryn Davies
1 84448 166 2
978-1-84448-166-8

Painting Unicorns in Watercolour
Rebecca Balchin
1 84448 165 4
978-1-84448-165-1

Painting Unicorns in Watercolour

REBECCA BALCHIN

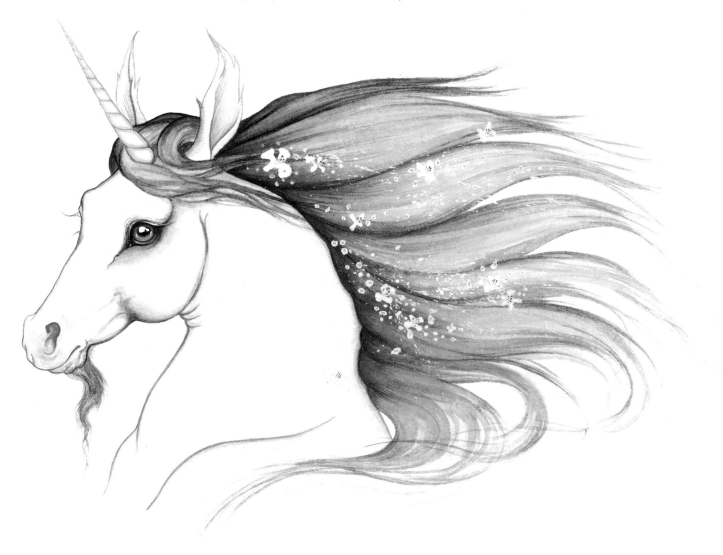

SEARCH PRESS

First published in Great Britain 2007

Search Press Limited
Wellwood, North Farm Road,
Tunbridge Wells, Kent TN2 3DR

Text copyright © Rebecca Balchin 2007

Photographs by Steve Crispe, Search Press Studios

Photographs and design copyright © Search Press Ltd, 2007

ISBN-10: 1-84448-165-4
ISBN-13: 978-1-84448-165-1

The Publishers and author can accept no responsibility for any consequences arising from the information, advice or instructions given in this publication.

The Publishers would like to thank Winsor & Newton for supplying some of the materials used in this book.

Suppliers
If you have difficulty in obtaining any of the materials or equipment mentioned in this book, then please visit the Search Press website for details of suppliers: www.searchpress.com

Publisher's note
All the step-by-step photographs in this book feature the author, Rebecca Balchin, demonstrating her watercolour painting techniques. No models have been used.

There are references to animal hair brushes in this book. It is the Publisher's custom to recommend synthetic materials as substitutes for animal products wherever possible. There is now a large range of brushes available made from artificial fibres, and they are satisfactory subsitutes for those made from natural fibres.

Cover

Into the Night Heaven

This was inspired by the timeless myth of the unicorn, at once wild and fearless and with a tremulous, shining beauty. I set the unicorn against a dark sky to create dynamic contrast with the pale tones of the unicorn's body and to help illuminate the fine tendrils of the mane and tail. Masking fluid was used to mask out the unicorn and preserve the white areas. I then flooded the background using a wet into wet technique, merging Prussian blue, ultramarine, phthalo turquoise and permanent mauve. The colours 'bloomed' into each other, producing a dramatic skyscape.

Acknowledgements

So many people have helped this book to happen! Firstly, thank you to Roz Dace, Sophie Kersey and the creative crew at Search Press for guiding me through the publishing maze. Thanks also to Stass Paraskos and the students at the Cyprus College of Art, July 2006, for artistic support, inspiration and yoga at dawn. Thank you Leybourne Riding School for lending cheeky chap 'Blue' for a mini photo shoot and also for reminding me how much I love horse riding. Last but by no means least, thanks to all my family for your love and support.

Dedication

This book is dedicated to Steve. I feel truly blessed to share my life with you. Bx

Page 1

Zephyr

The spring blossom still tangled in her mane, the unicorn raises her head to feel the first warm breezes of summer. To create the blossom, I used masking fluid to mask out small areas of the mane. I used cold colours to create the variegated mane: ultramarine blue and permanent mauve. Using the warm colours yellow ochre and burnt sienna for the eyes and horn in an otherwise cold-coloured composition draws attention to these elements.

Opposite

Long Ago Summers

A very limited palette has allowed me to focus on the composition and tonal values of this artwork. I used the warm colours Naples yellow, yellow ochre, burnt sienna and burnt umber, with a small amount of Payne's gray and titanium white for the eyes. Before starting, the whole paper was washed with a dilute mix of Naples yellow and burnt sienna. Broad brush strokes were then used to describe the unicorns' forms from this mid-tone. Using only light washes and a limited palette of warm colours, the final effect is as faded and fragile as a memory from long ago.

Contents

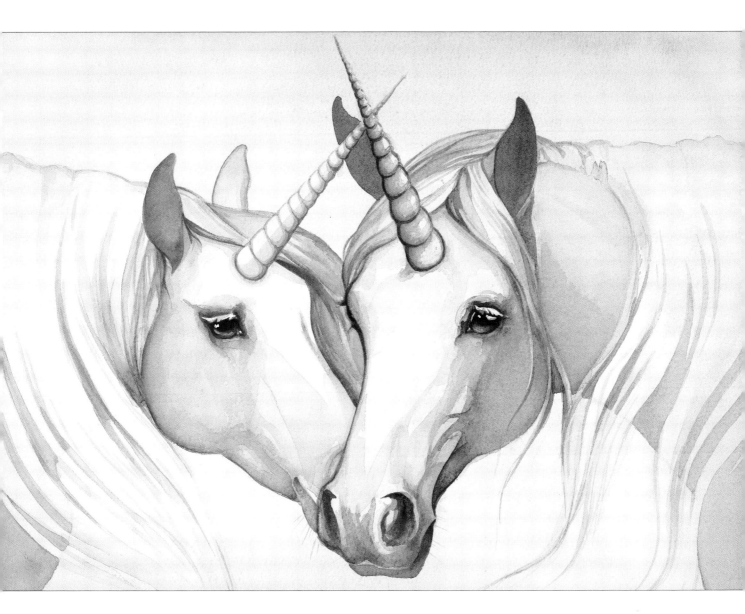

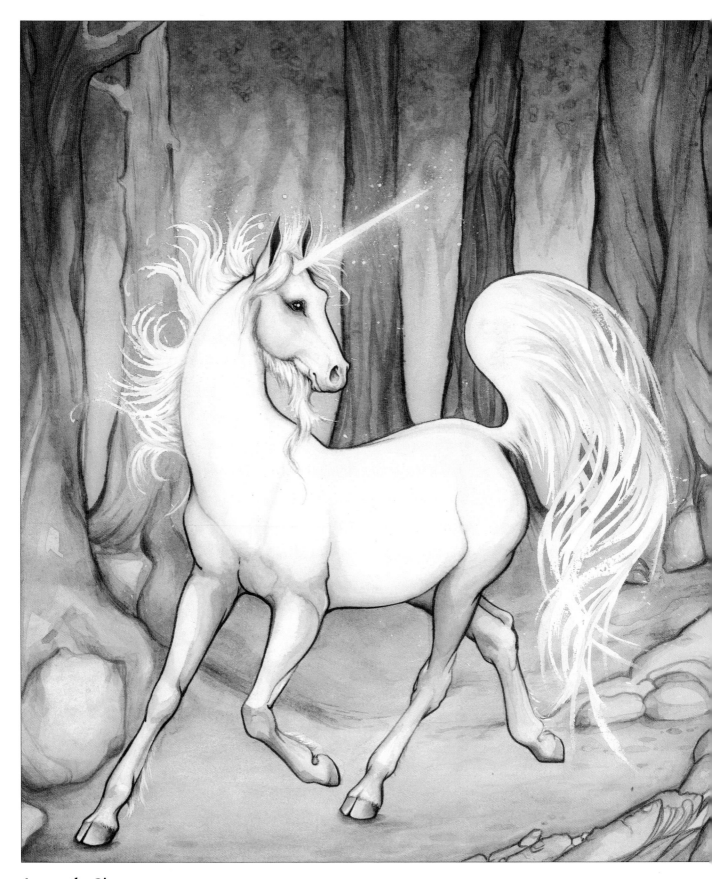

Among the Giants

This painting was inspired by the grandeur of the Troodos mountain forests in Cyprus, and was planned from drawings and colour sketches made on location. The entire unicorn was masked out with masking fluid, before several loose washes were applied to the background sections and trees. The wet into wet technique with salt crystal textures was used in the area behind the trees. Wet on dry was used for the trees in the mid- and foreground, rocks and unicorn. A toothbrush was used to spray a fine mist of masking fluid splatters around the horn to create a magical sparkle.

4

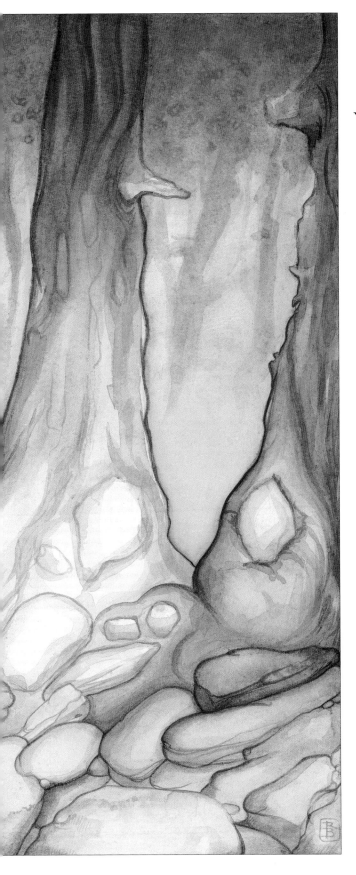

Introduction

Who hasn't stood at the edge of a great dark wood or forest and wondered what magical creatures may inhabit such a mysterious and brooding place? It is not such a large leap of the imagination to envisage a unicorn bounding through the woodland, its brave nostrils flared, holding us transfixed with a wild, beautiful eye.

The mythical unicorn has long been honoured through tapestry, folk song, poetry and stories. It is famed for its purity of heart, divinity and gentle wisdom. It is said that the unicorn's magical horn has the ability to heal the sick and wounded and that flowers will rise up from its cloven hoofprints through snowy ground. The most fantastic power a unicorn possesses is the ability to leap from the earth and form a magical rainbow in the sky.

The unicorn's majesty, grace and otherworldliness instantly capture the imagination and inspire the paintbrush. However, where do we begin when creating the image of a prancing, shining unicorn? We are lucky, as the majority of unicorns are created from creatures that are a little easier to find, such as horses, goats, lions or deer. The traditional, medieval unicorn would have borne the beard of a goat, the hooves, legs and body of a deer and the tail of a lion. To paint convincing unicorns, you will need to carefully observe and draw all these animals but in particular, horses. An excellent place to begin is by drawing from reference photographs. Try to draw ponies, horses and foals from life. Once you have grown in confidence, you can transform your drawings into your own unicorns.

Each of us holds an individual 'vision' of our unicorn and this book is here to help you learn some simple watercolour techniques so that you can paint that beautiful creature. Watercolour has an ethereal, translucent quality which is perfect for unicorns. Remember, the only limit of these fantasy paintings will be your imagination; your unicorn can be anything you wish it to be, perhaps beautiful, wild, shy, humble, shining, inquisitive or proud.

Lastly, I hope you find and meet your unicorn in that moonlit forest glade. Allow it to inspire you and I am sure that wherever you both may go, the journey will be magical. Enjoy your painting.

Materials

The beauty of watercolour is that you will need relatively few, inexpensive materials to start painting. An immense variety of artwork can be created with just a small range of paints, a basic selection of brushes, a mixing palette, watercolour paper, drawing pencils, paper tissues and clean water.

PAINTS

There are two main grades of watercolour paint, student and artist. If money is no object, buy the artist grade paints as they contain a higher proportion of pigment and create far brighter colours – essential for fantasy artwork. A high proportion of the artwork created for this book was produced with student quality paint however, still with excellent results.

Paints are available in both pans and tubes. Pans are designed to fit into a paint box and are more convenient for smaller artworks and painting on location. Tubes are excellent for adding vibrant details and for covering larger areas quickly for a broad wash. I would recommend using tube paints and starting with a small selection of student quality watercolours. You will need around ten to twelve colours. Include the primary colours as well as titanium white gouache for opaque highlights in areas such as the reflections in eyes.

A selection of watercolour paints in tubes.

BRUSHES

Watercolour brushes are usually made from either natural sable or synthetic fibres. As sable brushes hold large amounts of colour on the brush and maintain their shape through use, they are preferred by some professional watercolourists. Although they are expensive, it is worth purchasing a small selection of these brushes as they are a joy to paint with and if looked after carefully they will outlast other kinds of brush.

Synthetic brushes are far cheaper than sable, but do not carry as much paint and are more difficult to clean between colours. They have their own merits however, as they maintain their points, making them excellent for painting detailed areas. A compromise can be reached between natural and synthetic with brushes made of a mixture of the two. Sable and nylon brushes still contain some fine qualities of sable and can be purchased for less.

There are three main brush shapes: round, flat and mop. The round brush is the most versatile, as it can produce large areas of colour with the whole brush as well as fine details with the point. Flat brushes are used to create straight edges and chisel-shaped patterns. Mop brushes, or hake hair brushes are useful for rapidly wetting the paper and producing even washes over large areas.

Brush sizes are measured in numbers and range from 000 up to 20 and beyond. For the two projects in this book I have used numbers 0, 1, 2 and 4 for detailed work, numbers 8 and 10 for the bulk of the painting and a 19mm (¾in) flat brush for painting washes, clouds and skies.

A selection of natural and synthetic brushes used for watercolour painting, and toothbrushes which can be used for spattering paint.

PAPER

Watercolour paper is a thick, fibrous paper. It is strong enough to withstand the soaking and stretching required to prepare it for painting and yet it still has a surface with so delicate a texture that it can produce the most beautiful, detailed effects. It is important to select the best type of paper for the artwork you are producing. It is available in differing surface textures and weights (thicknesses).

There are three mains types of paper for watercolour, each with a different surface texture: hot-pressed (HP), cold-pressed (CP or Not) and rough. Hot-pressed paper has a smooth surface and is ideal for detailed linear work. Cold-pressed or Not paper is the most popular paper. It has a slightly textured surface and is a general purpose paper for all watercolour techniques. Rough paper has a coarse surface and is excellently suited to wet into wet techniques and loose brush work.

Watercolour paper comes in different thicknesses, which are measured in weight. There are several common weights available: 200gsm (90lb), 300gsm (140lb) and 600gsm (300lb), which is more like card. Heavyweight paper is preferable for broad colour washes to avoid the paper buckling as it soaks in the water. Medium-weight paper – 300gsm (140lb) – is a good weight for general work and was used for most of the artwork in this book.

Pre-gummed watercolour blocks are excellent when painting using wash techniques. The individual sheets of watercolour paper are glued together on all four sides, producing a non-buckling surface on which to work.

Sketchbooks, whether beautifully hand-crafted or simply spiral-bound, are useful for drawing whilst on location. Use them to record thoughts and visual ideas.

Various weights and textures of paper, with a watercolour block and sketchbooks.

OTHER ITEMS

Pencil You will need several grades: hard (H), medium (HB), and soft (B). All three pencils can be used when producing sketches for your compositions. Use the (H) grade pencil when drawing out final compositions on watercolour paper, to avoid any smudging.

Eraser Use a soft putty eraser, as harder ones can damage watercolour paper.

Palette Traditional china palettes make colour mixing easier and are heavy enough to stay still when being used. Alternatively use a plastic palette.

Water pot Stability is important when selecting a water pot.

Kitchen paper Make sure you have a good supply for mopping up spills and cleaning brushes between colours and for lifting out techniques.

Cotton buds Use cotton buds to lift out small areas of colour.

Masking tape Use masking tape to secure your paper to the drawing board.

Gummed tape Brown gummed tape is used when stretching wet watercolour paper on a drawing board.

Masking fluid For masking out small areas of paper before painting.

Salt Rock salt crystals can be bought cheaply from any supermarket. Applied to wet paint, they draw in the pigment and water and dry to form star shapes around the grains.

Old paintbrush Always use an old paintbrush when applying masking fluid as the residue is hard to remove from brushes and can ruin them.

Toothbrush This can be used to splatter either paint or masking fluid on to the paper to create spray effects. Practise on a spare piece of paper first!

Natural sponge Use natural sea sponges to produce delicate patterns wet on dry.

Ruler Use to scale up sketches or as a guide when drawing horizon lines.

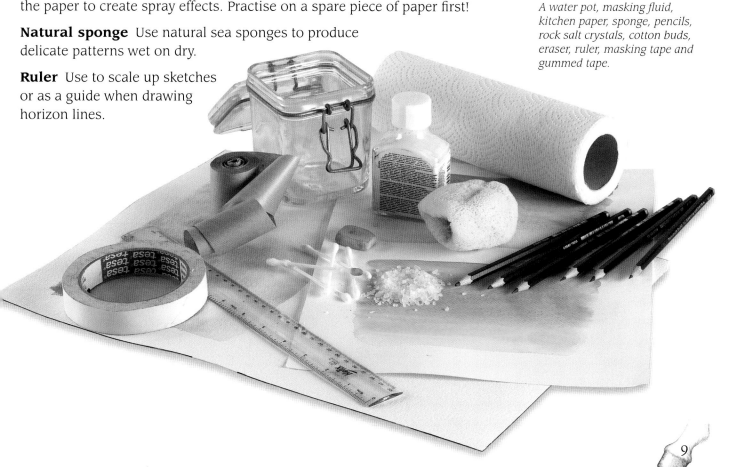

A water pot, masking fluid, kitchen paper, sponge, pencils, rock salt crystals, cotton buds, eraser, ruler, masking tape and gummed tape.

Colours

The colours you select for your painting can dramatically affect the atmosphere of the composition. Take time in the planning of your painting to produce several coloured thumbnail sketches to explore different possibilities and see how the changes affect the overall mood of your painting.

In general, primary colours suggest youth, energy and vibrancy. Pastel shades evoke whimsical innocence whereas darker tones and mixes can express a sinister nature, laced with edgy foreboding. Warm colours – red, yellows and oranges, convey a sense of happiness and positivity, whereas cold colours – blues, greens, purples – can produce a calm and reflective mood.

Traditionally, unicorns are white, enhancing the myth of their purity and divinity, but a unicorn may equally well be a stormy midnight black, or a warm, glowing gold or even soft indigo. I find it helpful to limit my palette to two main colours. These are often harmonious colours, which are next to each other in the colour wheel, for example, a warm yellow and orange. Select one colour for the main body of the unicorn, then work the second colour into the legs, hooves, horn, tail and mane. When creating a composition, practise with different colour combinations for both the unicorn and the background. Personal taste and intuition may guide you, but as a rule of thumb, avoid using too wide a range of colours for any one painting. Often a simple palette of four or so main colours is more effective and will produce a harmonious final result.

This palette shows the colours I have used for the two project paintings in this book.

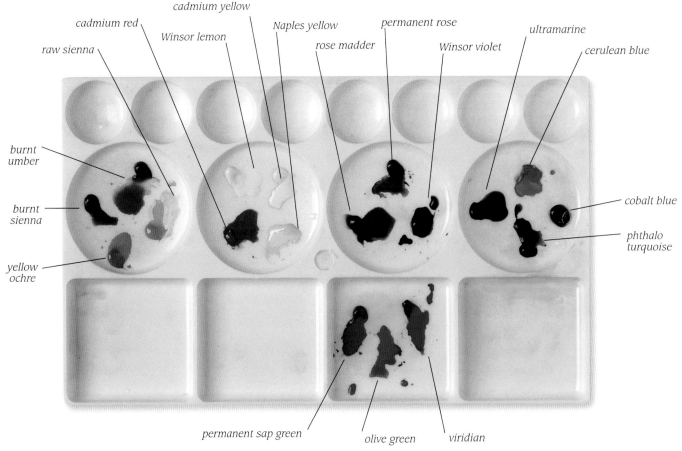

cadmium yellow

cadmium red

Winsor lemon

Naples yellow

permanent rose

ultramarine

raw sienna

rose madder

Winsor violet

cerulean blue

burnt umber

burnt sienna

cobalt blue

phthalo turquoise

yellow ochre

permanent sap green

olive green

viridian

10

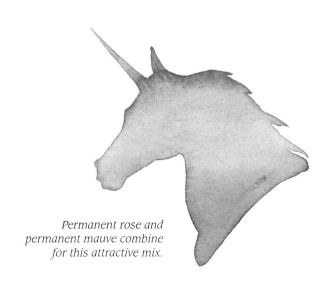

Permanent rose and permanent mauve combine for this attractive mix.

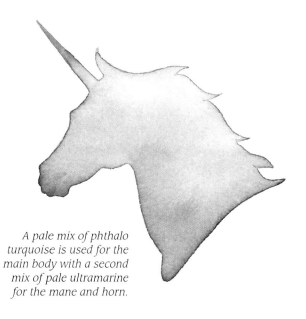

A pale mix of phthalo turquoise is used for the main body with a second mix of pale ultramarine for the mane and horn.

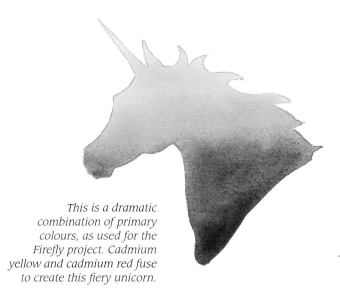

This is a dramatic combination of primary colours, as used for the Firefly project. Cadmium yellow and cadmium red fuse to create this fiery unicorn.

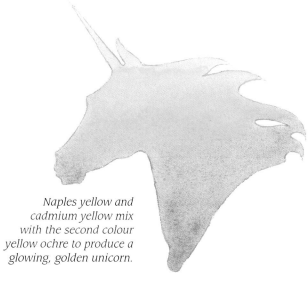

Naples yellow and cadmium yellow mix with the second colour yellow ochre to produce a glowing, golden unicorn.

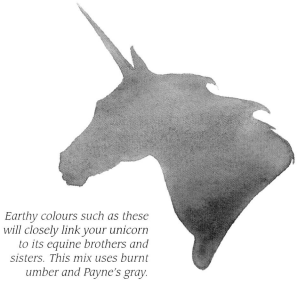

Earthy colours such as these will closely link your unicorn to its equine brothers and sisters. This mix uses burnt umber and Payne's gray.

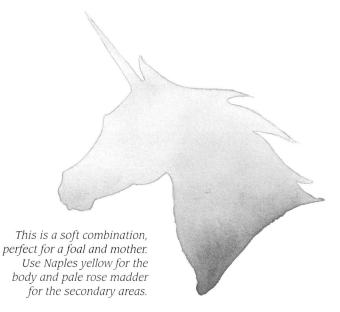

This is a soft combination, perfect for a foal and mother. Use Naples yellow for the body and pale rose madder for the secondary areas.

Techniques

There are a huge number of techniques available to a watercolour artist, but only a few are needed to be able to create wonderful effects. This section will help you build up the confidence to go on to develop your own repertoire and unique approach.

WASHES

Creating a wash is one of the basic techniques of watercolour painting. It is the easiest way to lay colour on the paper and create a subtly graded background. When painting the wash it is important to complete it in one quick session, so mix up plenty of paint beforehand.

A FLAT WASH

The finished flat wash.

Wet the paper first with a size 12 brush. Mix ultramarine and cerulean blue and paint on the wash with horizontal strokes of the brush.

A GRADED WASH

The finished graded wash.

Wet the paper first. Apply the paint from the top, but this time add water to the mix towards the bottom.

A VARIEGATED WASH

The finished variegated wash.

Wet the paper first. Apply a cadmium red and cadmium yellow mix with horizontal strokes. Add more yellow towards the bottom.

WET INTO WET

This classic watercolour method, as the name suggests, involves dropping wet paint into areas of still wet wash. As the colours run into each other, 'blooms' form, creating soft, organic results. This technique is especially good for producing clouds and was used for the cover image of the book.

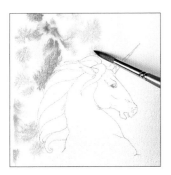 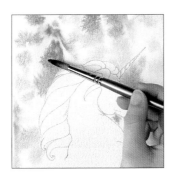 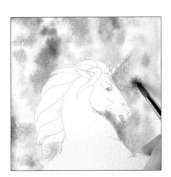 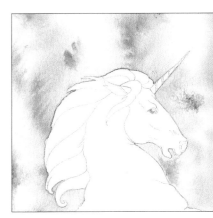

1 Wet the whole area apart from the unicorn with a no. 10 brush. Drop in Prussian blue.

2 Drop in a little phthalo turquoise while the Prussian blue paint is still wet.

3 Still painting wet into wet, drop in permanent mauve. Watch the colours spread and mix on the page.

The finished unicorn.

WET ON DRY

Once a wash is completely dry, it is possible to apply a new, wet layer of accurate brush work on top. The brush can be used to draw with a considerable amount of detail, effortlessly shaping contours and adding areas of depth and colour. This technique was used extensively throughout the artwork featured.

 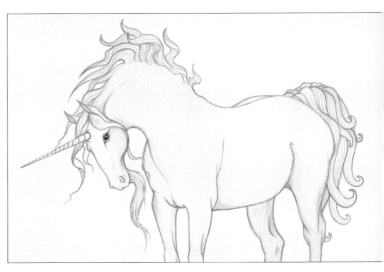

1 Paint the unicorn with a thin mix of Naples yellow and Turner's yellow. When this is dry, paint the detail using a no. 00 brush and a strong mix of raw sienna and yellow ochre. Work around the forelock and define the face and mane. Paint the eye using ultramarine.

2 Continue working wet on dry with the stronger mix, defining the shape of the unicorn's legs and adding detail to the mane and tail. Add a little burnt sienna to the mix where you need to brighten darker areas.

MASKING

Small areas of white or underlying colour can be preserved using masking fluid. It works well with complicated shapes that would normally be difficult to paint around, such as magical sparkles around a unicorn's horn, the flowing tendrils of a mane and tail or the highlight in an eye.

1 Draw the unicorn. Use an old no. 0 brush to paint masking fluid over the whole shape.

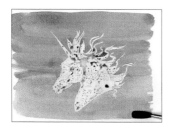

2 Mix ultramarine and phthalo blue and wash over the masked unicorn shape using the no. 8 brush.

3 When the wash is completely dry, rub off the masking fluid using an eraser or clean fingers. You can pull some of it off as shown.

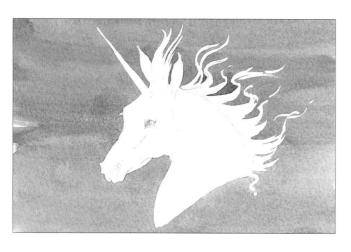

The finished unicorn.

SALT

Rock salt crystals can be scattered on to a wet wash. As they dry, they absorb water and pigment, and star-shaped auras appear. It is particularly effective when used with darker tones. Large crystals will produce very distinctive shapes; smaller crystals produce a finer patterning.

1 Make a wash from viridian and permanent sap green. Drop in olive green wet into wet.

2 While the wash is wet, sprinkle on some salt crystals.

3 Allow the painting to dry. The salt absorbs some of the paint, creating an interesting effect.

LIFTING OUT

Kitchen paper can be used to 'lift out' or remove colour from damp watercolour paper. Tear off and crumple up a piece of kitchen paper, then twist it between your thumb and forefinger to create a thin pad. Using the pad, carefully dab away the damp colour. Subtle glowing effects around stars and horns are easily achieved in this way.

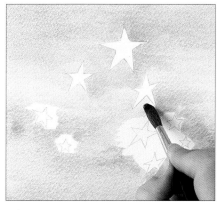

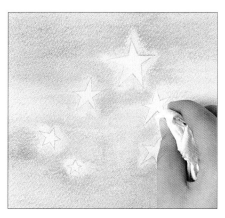

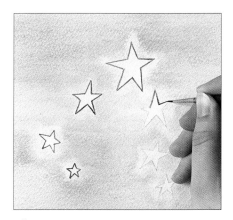

1 Draw the stars in pencil, then paint a flat wash of ultramarine behind them using a no. 8 brush.

2 While the paint is still wet, lift out paint around the edges of the stars using kitchen paper.

3 Use a no. 00 brush and a stronger mix of ultramarine to outline the stars.

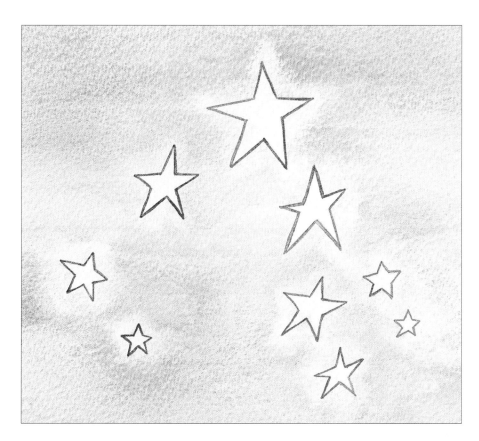

The lifting out technique creates a glowing effect around the stars.

Drawing unicorns

Your fantasy painting will begin with sketching. As many unicorns follow an equine (horse) body shape, we will look to the horse to form the main body of the unicorn. Drawing a horse can be challenging at first and you may have to try several times, but all it takes is a little practice.

DRAWING A HORSE

Collect reference photographs of horses, foals and ponies, looking for a range of different stances and expressions. Excellent photographs of galloping horses can be located in the sports pages of a newspaper. Select an image, then try laying a sheet of tracing paper over the photograph and tracing out the simplest shapes to guide you. Break down the structure into ellipses, triangles and circles, then go on to draw in the finer details as shown below.

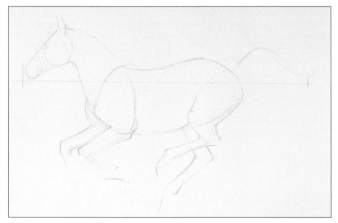

1 Use an HB pencil. Mark a horizontal line across the length of the horse, and mark the tip of its nose and the end of its tail at either end of the line. Now sketch in the basic shapes of the head, neck, body, legs and tail.

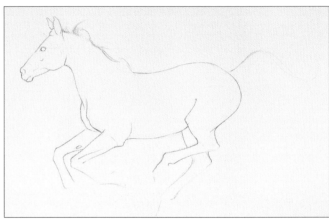

2 Tighten up on the outline of the horse, using your reference photograph as a guide and rubbing out your basic construction lines as you go.

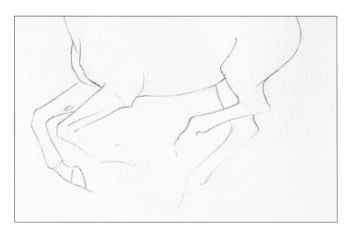

3 Work on the feet and hooves. Draw a dividing line between the leg and the fetlock. Then put in a line for the angle at the top of the hoof, and one for the bottom of the hoof.

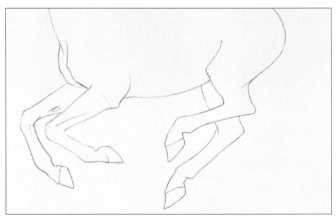

4 Complete all the hooves in this way.

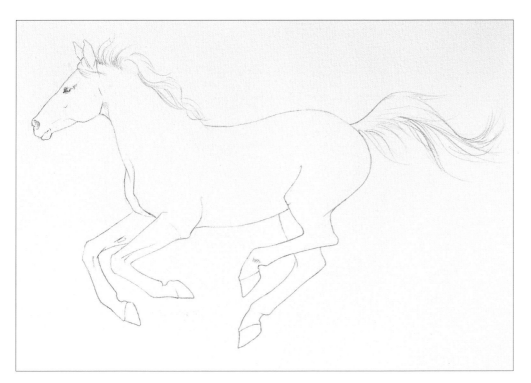

5 Add detail to the whole horse, working on the eye, nostril, mane and tail.

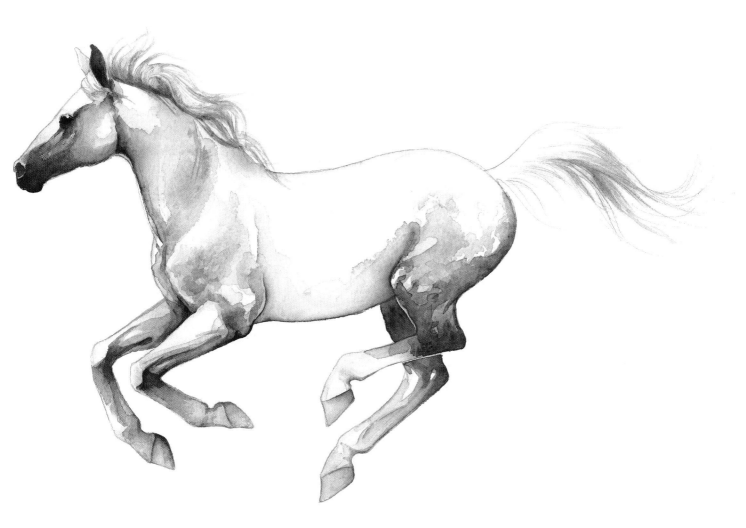

The horse here is shown mid-gallop. Inspiration was taken from race horses in newspaper sports pages. Both the mane and tail stream behind the animal, emphasising movement.

FACES

Much of the unicorn's character will be defined by the facial expression and head carriage. The spirited unicorn will carry its head high, both ears pricked and alert. A frightened unicorn will switch its ears back against it head, flaring its nostrils.

Horses' head shapes can vary considerably depending on gender and age. When portraying a mare, use slender, soft shapes and a large eye. Foals have domed foreheads, large eyes, even larger ears and small muzzles. When drawing a stallion, emphasise the jaw and musculature of the neck.

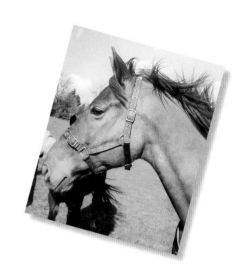

1 You need to position your subject centrally on your paper. Using the HB pencil, make a mark for the point of the nose, and another for the top of the head. Mark the shape of the neck.

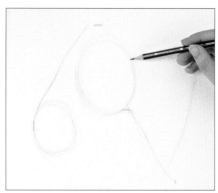

2 Sketch in the basic shapes of the horse's face.

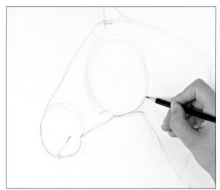

3 Continue marking more basic shapes, including the ear and the line of the mouth.

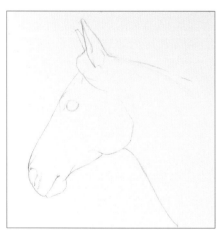

4 Rub out your construction lines and add more detail to the ears, nose and eye.

5 Work on the final details, adding lines and tone to the eye, sketching in the mane and adding some shading.

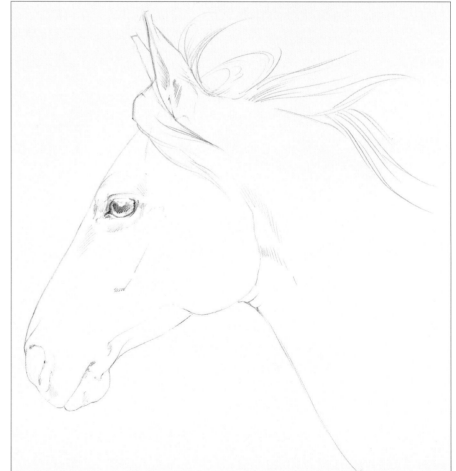

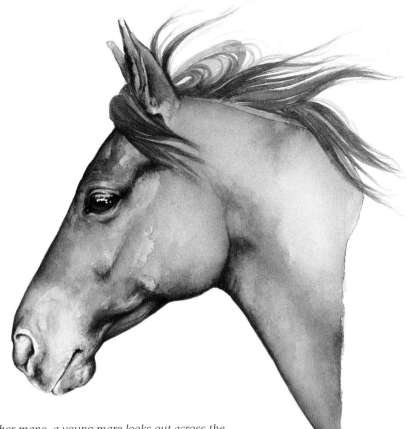

The eye is the
most important
part of the face as it communicates
character. Draw the eye carefully,
as the tiniest variations in size
and position can greatly alter the
character of the horse. Always add a
highlight to the eye to create a sense
of life and presence. Titanium white
can be used to produce an opaque
highlight. Try enlarging and elongating
the eyes slightly when transforming
your horse into a unicorn.

*As a warm breeze ruffles her mane, a young mare looks out across the
meadow. Inspiration was taken from my own reference photograph taken at
a local riding stables. Working from photographs of horses in profile can be a
helpful tool when first starting to draw and paint them. The colours are yellow
ochre and burnt sienna with a hint of cobalt blue around the eye and muzzle.*

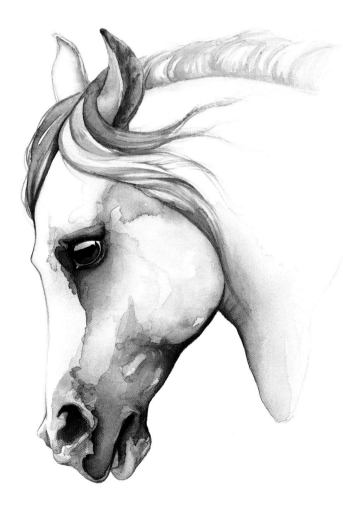

*This grey steed was painted using
Payne's gray and very pale washes
of burnt sienna, ultramarine and
permanent mauve. The washes were left
to dry with hard edges to emphasise the
dappled patterning of the coat around
the face. A mix of permanent rose and
rose madder were used for the pink areas
around the muzzle. The flex and crest
of the neck suggest this is a stallion, as
does the strong jaw bone. Note the flared
nostrils and position of the ears. These,
along with the open eye showing white,
communicate both fear and anger. The
iris was painted with cobalt blue and the
pupil with neutral tint.*

19

HORNS

The style of your unicorn's horn is an entirely personal choice. There is an array of living creatures to refer to such as goats, antelope, deer or cattle. The horn may be straight; curved backward; spiralled like the tusk of a narwhal; totally smooth; rough like tree bark; or take the more complex form of a goat-like curl. Here are some styles to get you started.

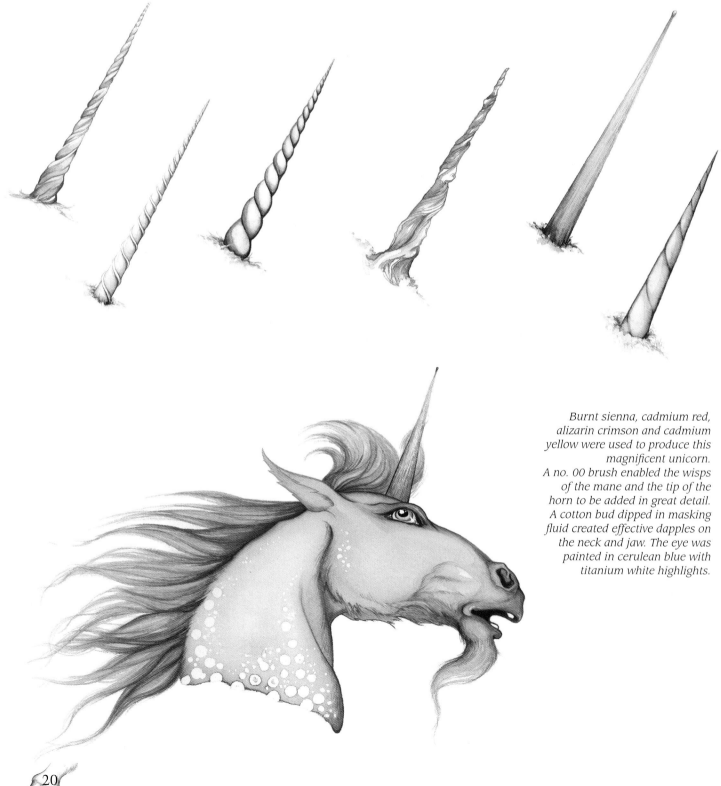

Burnt sienna, cadmium red, alizarin crimson and cadmium yellow were used to produce this magnificent unicorn. A no. 00 brush enabled the wisps of the mane and the tip of the horn to be added in great detail. A cotton bud dipped in masking fluid created effective dapples on the neck and jaw. The eye was painted in cerulean blue with titanium white highlights.

MANES

A unicorn's mane can be used to help create its character. The mane frames the unicorn's face and horn and can also create a dynamic composition. Manes need not be the same colour as the unicorn's body, but may instead be painted in a harmonious or gradated colour. Experiment with light, wavy manes; curly manes which hang close to your unicorn's neck and face; or upright manes, which suggest an inquisitive, energetic nature. Add flowers, ribbons, stars or even bubbles – above all, experiment. Remember, there are no rules!

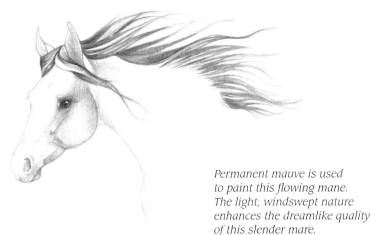

This colt has a curly, upright mane. It is painted with a range of natural colours, starting at the forelock with burnt umber, burnt sienna and merging to yellow ochre near the shoulders.

Permanent mauve is used to paint this flowing mane. The light, windswept nature enhances the dreamlike quality of this slender mare.

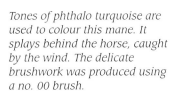

A pale mix of ultramarine and neutral tint is used to create these heavy locks. The unicorn's beard mirrors the curls in the mane.

Tones of phthalo turquoise are used to colour this mane. It splays behind the horse, caught by the wind. The delicate brushwork was produced using a no. 00 brush.

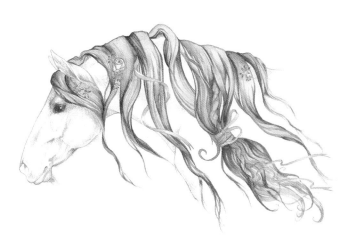

Flowers, ribbons and plaits adorn this fantasy mane. Permanent rose was used to produce the stunning, pink mane into which lemon and cadmium yellow roses and ribbons have been woven. Several wet on dry layers were added to achieve areas of deep tone.

TAILS

In nature, the position and movement of a horse's tail help it to communicate feelings with other horses. For example, an excitable horse will raise its tail in welcome to a fellow horse and an agitated animal will switch its tail irritably from side to side. Tails are also extended for balance when a horse is rearing, jumping and galloping.

In medieval unicorn mythology, the unicorns of tapestries and writings are described as bearing the tail of a lion. Delicate, goat-like unicorns may well suit the traditional lion's tail, but you should ideally dress your unicorn to the needs of its character. Larger, stronger unicorns may suit fuller tails. When deciding on a suitable tail, take the unicorn and the composition into account. As with manes, a tail can make a dashing addition to your mythical beast and bring colour and atmosphere to your painting. After having taken all these individual elements into account, make sure that the mane, forelock, tail and feathers around the hooves are similarly matched in colour and type.

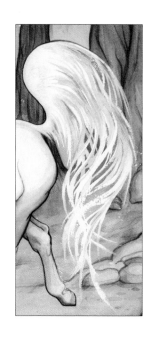

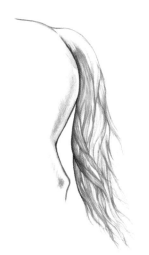

Wet on dry technique with a no. 0 brush is used to produce the very fine detail in this tail. Phthalo turquoise and ultramarine are blended to create areas of depth.

Limiting the palette to Naples yellow and yellow ochre has kept this tail a light golden hue. Individual tendrils have been separated and hang freely creating an attractive, layered texture.

This full tail was created with subtle mixes of permanent mauve and ultramarine. It is far removed from the naturalistic painting of the first tail, having been stylised into a graphic representation.

The traditional medieval unicorn's tail resembles that of a lion. In this illustration a yellow ochre wash was used for the unicorn's body and burnt umber was then used wet on dry to add form and detail.

A second version of the lion's tale. The silver effect is produced by using Payne's gray.

22

HOOVES

The hooves of your unicorn can be developed from horses' hooves. You must first understand the basic structure and articulation of the horse's lower legs, fetlock joints and hooves, so practise drawing from reference or observation.

Once again, it is the character of your unicorn that will govern what kind of hooves you choose to give it. Traditional horses' hooves indicate strength and dynamism. Goat-like, cloven hooves suggest purity, humility and surefootedness. They can be drawn from reference images of goats or deer. Pay particular attention to the feathers – the hair around the hooves – as these can be extended into long, wavy, flowing hair, adding character and movement. Try using salt to create texture or try painting a pattern of tiny spirals or heart shapes on the underside of the hooves – there are endless possibilities.

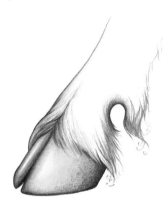

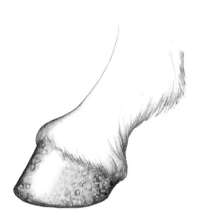

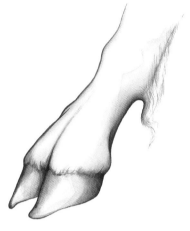

Using a range of warm hues including yellow ochre, cadmium yellow, raw sienna, burnt umber and burnt sienna, this cloven hoof has its roots in medieval tapestries. Note the faint spiral pattern across the hoof surface and the delicate feathers.

This was inspired by a typical horse's hoof. The colours are permanent mauve, Winsor violet and Prussian blue. Salt crystals were added to the hoof area to produce star-like blooms across its surface.

Using reference from goats, this narrow cloven hoof was painted using Naples yellow and rose madder. Details were then added wet on dry using a strong mix of cadmium red and burnt sienna.

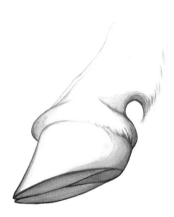

The underside of a cloven hoof showing the divisions. Phthalo turquoise was used for this study. A pale wash of Payne's gray adds depth to the shadow on the underside of the hoof.

The feathers play an important role around the hooves, adding drama. Rose madder was used for the main colour. A light wash of burnt umber was painted on the underside of the hoof to add tonal depth. Faded spirals were added using a mix of permanent rose, burnt umber and Payne's gray.

This view shows the cloven hoof from the front, in a study of form and tone. Payne's gray was used to sculpt this lifelike representation.

MOVEMENT

The horse and its mythical cousin the unicorn are both creatures who are born to run. Whether they are rearing, galloping, turning or jumping, they display an effortless combination of strength and grace. It is an excellent idea to watch a local horse show to appreciate truly the magnificence of the horse in movement. Observe how the whole outline of the horse alters as it changes pace: from the relaxed walk to the energetic trot through to the smooth canter. Capturing this convincingly can be daunting, so it is often helpful to begin by working closely from good reference photographs.

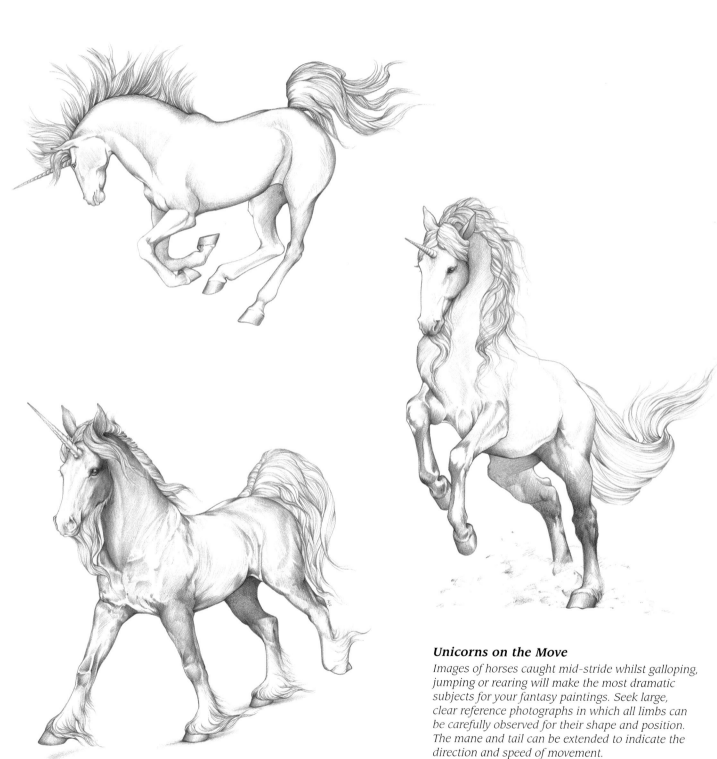

Unicorns on the Move
Images of horses caught mid-stride whilst galloping, jumping or rearing will make the most dramatic subjects for your fantasy paintings. Seek large, clear reference photographs in which all limbs can be carefully observed for their shape and position. The mane and tail can be extended to indicate the direction and speed of movement.

Patchwork Magic

A unicorn at rest can be the subject of a peaceful and magical painting. This serene unicorn quietly rests in a nest of richly patterned fabrics. Many sketches were made from reference images to make sure the unicorn's legs are positioned in a life-like manner. I enjoyed the challenge of painting the folded, patterned fabrics and found it very helpful to set up a small fabric still life in the studio. The main body was painted with subtle tones of Payne's gray mixed with neutral tint, whilst the horn and hooves were created with a mix of burnt umber and yellow ochre.

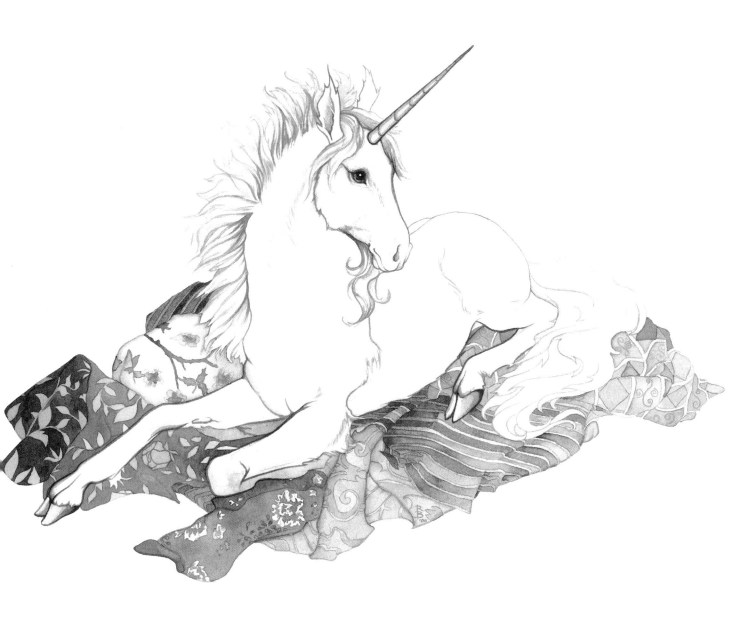

Overleaf
Taming the Waters

This painting was inspired by a walk along a wild coastline at dusk. After the drawing was completed, a pale wash of Naples yellow and rose madder was applied to the sky area with a large flat brush. Strong mixes of permanent mauve, then Naples yellow, permanent rose and rose madder genuine were then dropped into the sky wet into wet. This created cloud-shaped 'blooms'. The sea was painted with a mix of French ultramarine and phthalo turquoise using large, fluid brush strokes, saving areas of white for highlights. The unicorn's body is illuminated by the glowing sunset, so its highlights contain colours from the sky.

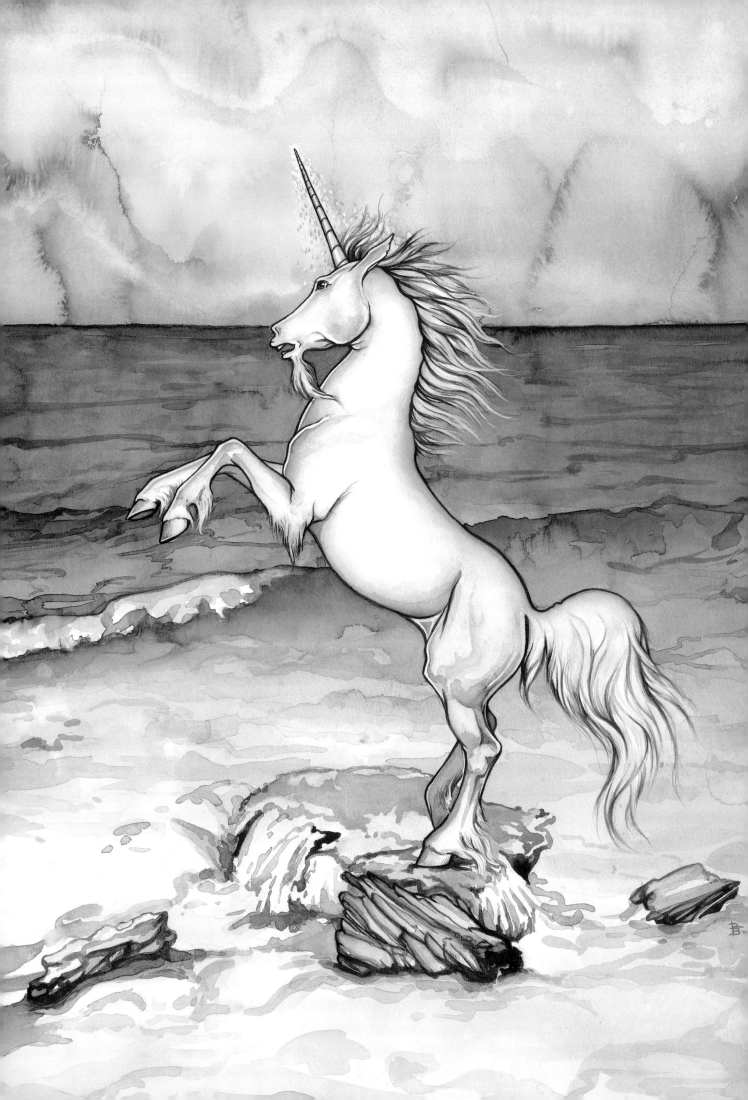

Pink Moonrise

As a pale moon rises in a pink glow, dusk settles over the unicorn's domain. This is an uncomplicated, gentle painting that relies on wet-on-dry techniques over pale washes to create texture and movement through line. The entire composition was given a variegated wash using a pale mix of Naples yellow, Turner's yellow and rose madder. While the paint was still wet, I lifted out the moon area and the unicorn's body with a soft tissue. I used a fine brush, wet-on-dry to paint the unicorn's outline with a mix of burnt sienna and Turner's yellow. A pale wash of permanent mauve was used for the rocks and a light wash of permanent sap green and viridian was added to the grass area. I used more intense mixes of these colours to add fine, wet-on-dry details.

FOALS

Foals have a natural magic all of their own. Their large dark eyes, inquisitive features and sense of play endear them to many and can bring a touch of humour to your paintings. There are several differences between grown unicorns and their foals other than size. Firstly, the foal's most striking feature is its rather long, awkward legs. Their faces are characterised by large, expressive eyes, over-sized ears and domed foreheads. Lastly, foals' manes and tails are usually short and fairly stubby in comparison to those of their fully grown parents.

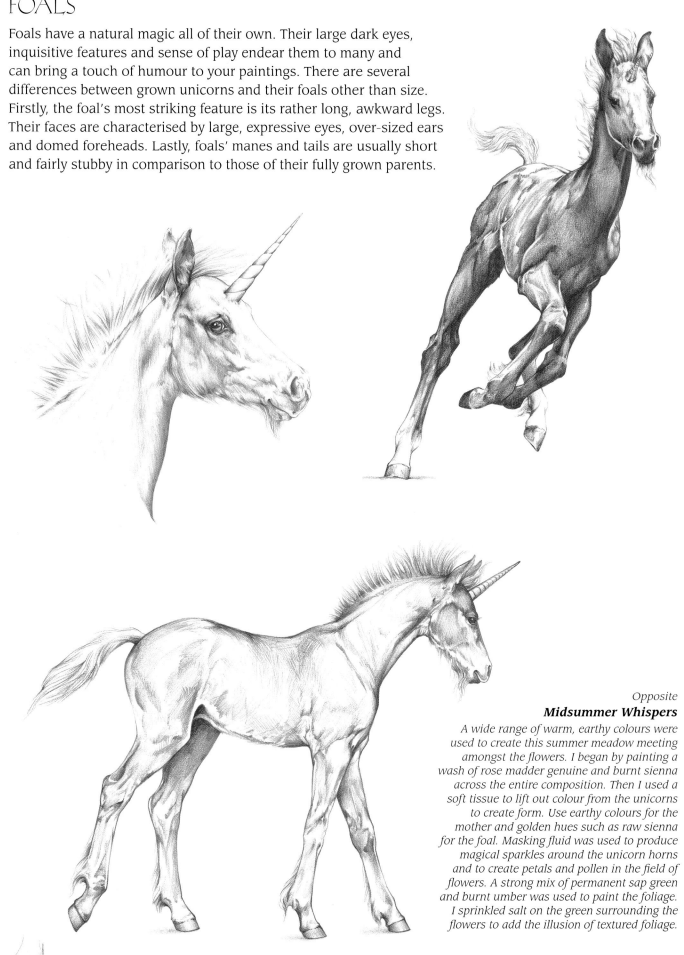

Opposite
Midsummer Whispers
A wide range of warm, earthy colours were used to create this summer meadow meeting amongst the flowers. I began by painting a wash of rose madder genuine and burnt sienna across the entire composition. Then I used a soft tissue to lift out colour from the unicorns to create form. Use earthy colours for the mother and golden hues such as raw sienna for the foal. Masking fluid was used to produce magical sparkles around the unicorn horns and to create petals and pollen in the field of flowers. A strong mix of permanent sap green and burnt umber was used to paint the foliage. I sprinkled salt on the green surrounding the flowers to add the illusion of textured foliage.

28

Backgrounds

The use of backgrounds in your compositions can help to focus, direct and amplify the mood and narrative of a painting. Select dark, brooding tones and jagged forms such as rocky outcrops to convey charged, stormy emotions, for example. Whether you place your unicorn against a dramatic night sky with a silver moon floating overhead, or under a magical tree, or over a rainbow, the ideas in this next section should help to get you started.

SKIES

The sky in a fantasy world can be any colour you wish it to be. Below is an example of billowing white clouds in a fresh blue sky, but you may choose to experiment with red, pink, purple, midnight blue or flame-coloured skies. You may even wish to take inspiration from the icy hues of the spectacular aurora borealis.

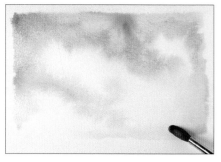

1 Wet the sky area with the no. 12 brush and clean water. Mix a wash of ultramarine and cerulean blue and apply it with the same brush, implying cloud shapes as you paint.

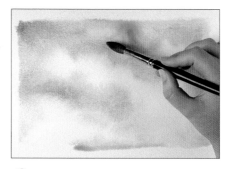

2 Mix ultramarine and burnt umber and drop in darker clouds wet into wet.

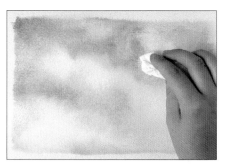

3 Use kitchen paper to lift out colour, redefining the sunlit edges of the clouds.

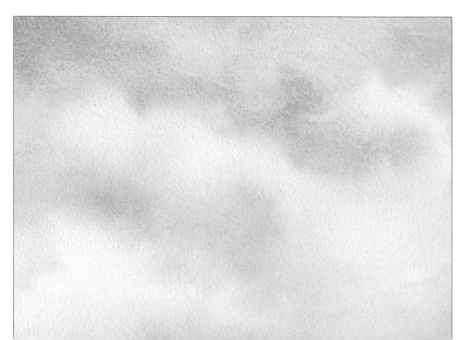

The finished sky. Wet into wet paintings like this change as they dry, so you will need to wait to see the finished effect.

RAINBOWS

The most magical element of any fantasy landscape, a rainbow is an ethereal symbol of hope. It is fabled that the unicorn can create a rainbow from one single leap into the air. To create both of these rainbows I used cadmium red, cadmium yellow, permanent sap green, French ultramarine and permanent mauve and worked wet into wet with a large, round brush. Experiment and vary the strength of the paint mix to produce pale or more intense rainbows.

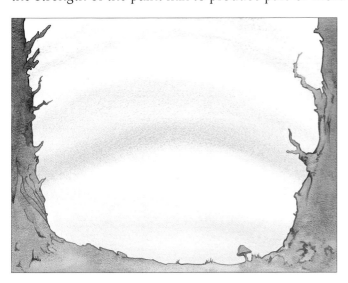

MOONS

The moonscape on the left is relatively simple to produce. Once the drawing is complete, use masking fluid to retain the white in the area intended for the moon. Then paint a smooth, variegated wash on damp paper using French ultramarine and permanent rose. Next remove the masking fluid and paint the remainder of the moon. Lastly paint the rocks using a permanent rose and permanent mauve mix.

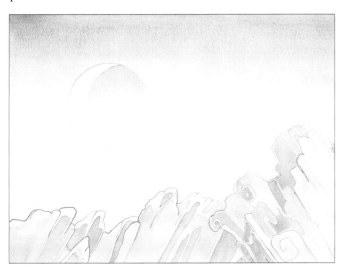
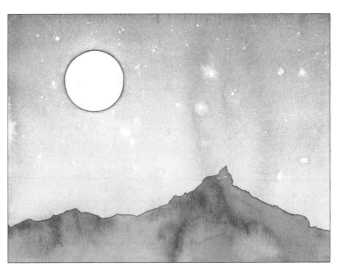

The full moon on the right is painted in high detail. Mask off the area intended for the moon and the centre of the stars prior to painting. Then paint a mix of Prussian blue and French ultramarine to create the sky. Use titanium white gouache to add further shine around the stars. Finally paint the mountain range using a permanent mauve and Prussian blue mix.

ROCKY SCENERY

If possible, look in natural history journals to find reference for rocky scenery. Images of snow-capped mountains, immense canyons and seashore cliffs can all be used with dramatic effect. Go on to further develop initial sketches using your imagination to add strata, spirals, arches and caves.

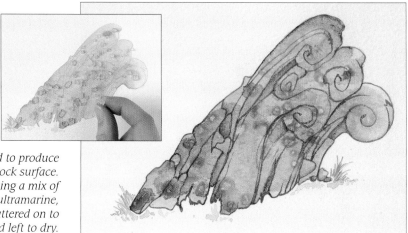

Here salt crystals were used to produce additional textures on the rock surface. The rock was painted using a mix of burnt umber and French ultramarine, then salt crystals were scattered on to the paint and left to dry.

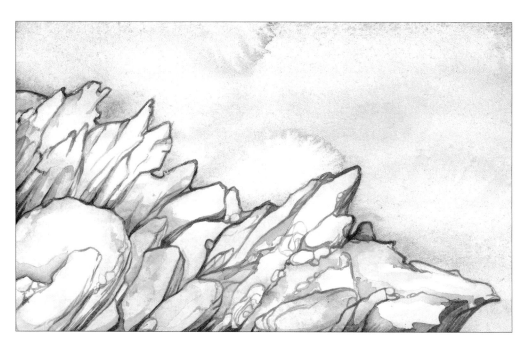

Rocky outcrops provide a dramatic platform for unicorns. In this example the rocks were coloured with tones of permanent mauve. You can experiment with various shades of blue, grey and brown.

In this illustration, the rocks were painted with Payne's gray and the grass with a mixture of permanent sap green and viridian. These overgrown, mossy plateaus are a favourite resting place for unicorns.

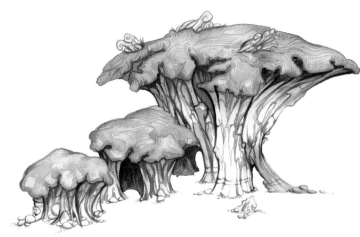

FORESTS

What better backdrop for your unicorn than the mystical heart of an enchanted forest? It is here that the shy unicorn makes its secret home. To begin, find and sketch from inspirational images of ancient woodland and forests. As starting points, look for photographs taken in different seasons: a bluebell wood in April or an autumnal thicket in October. Better still, take a walk with a sketchbook and seek inspirational trees. There may even be a 'unicorn tree' at the bottom of your own garden.

A slender, gently turning lilac tree mimics the twisting nature of a unicorn's horn. Permanent mauve and raw sienna were used to paint the lilac leaves. Salt crystals create texture among the foliage.

In this study I enjoyed exaggerating the quality of knarled bark. Imaginative sketches helped me develop the suggestion of human faces in the wizened tree trunk. I used burnt umber and burnt sienna with small amounts of Winsor violet dioxazine, viridian, phthalo turquoise and permanent mauve.

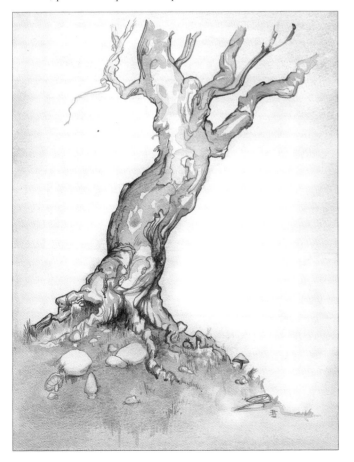

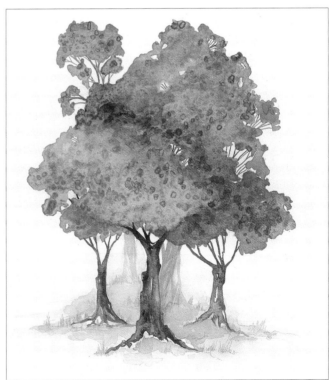

Grouping trees together as in woodland allows for a visual 'shorthand' in which foliage may be merged. Select two or three trees at the front or edges of the group to add which to add detail. Here salt crystals were used to create leaf textures.

Firefly

A spirited unicorn leaps into an azure sky in a fiery display of exuberance. This vibrant composition draws together several simple watercolour techniques to produce a striking artwork. You have the chance to use wash techniques, masking, lifting out, wet into wet and wet on dry. The plain background makes it possible to concentrate almost entirely on the unicorn, so that you can perfect the illusion of form through colour blending and fine line painting, using wet on dry techniques.

YOU WILL NEED

H pencil

300gsm (140lb) rough watercolour paper, 59.5 x 41 cm (23½ x 16¼in)

Masking fluid and old paintbrush

Kitchen paper

Eraser

Cotton bud

Paints: ultramarine, cerulean blue, phthalo turquoise, cadmium yellow, cadmium red, yellow ochre, Winsor yellow, burnt umber, burnt sienna

Brushes: 19mm (¾in) flat and numbers 00, 1, 2, 4 and 8 round

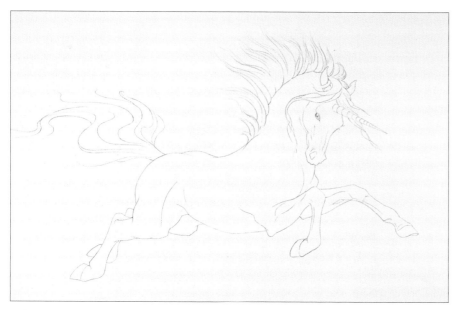

1 Draw the unicorn using an H pencil.

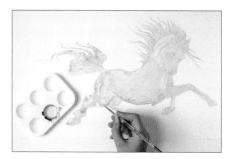

2 Use an old paintbrush and masking fluid to mask the whole unicorn.

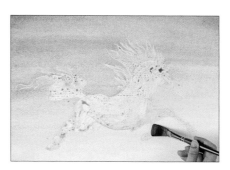

3 Wet the paper using clean water. Make a lighter and a darker mix of ultramarine and cerulean blue. Paint the darker mix from the top using a 19mm (¾in) flat brush, graduating to the lighter mix at the bottom.

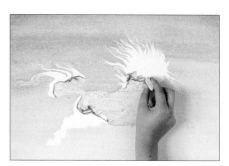

4 When the first wash is dry, paint another wash of phthalo turquoise mixed with cerulean blue over the top, to deepen the colours.

5 Remove the masking fluid using an eraser or clean fingers.

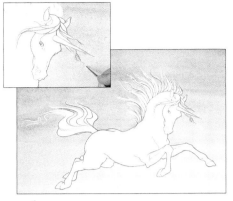
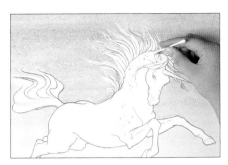
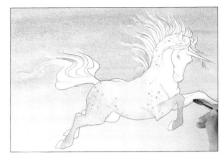

6 Use a no. 1 brush and a mix of cadmium yellow and cadmium red to outline the whole unicorn. This should be done slowly and very carefully.

7 Dip a cotton bud in masking fluid and dab on the unicorn's dapples. Vary the size so that they look natural.

8 Mix a thin wash of cadmium yellow and a little cadmium red. Using the no. 8 brush, fill in the unicorn, beginning with the back legs. Add water as you go to lighten the rump and across the shoulders. Load up with paint for the front legs.

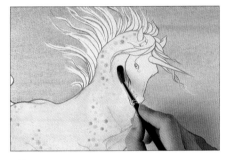
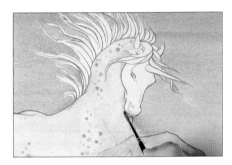
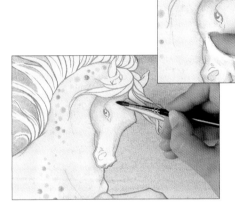

9 Paint up to the unicorn's face using the no. 8 brush.

10 Change to the no. 4 brush and add shadow under the unicorn's face.

11 Make a thicker, redder mix of the two colours and paint the edge of the cheek and under the forelock. Blend the edge of the paint with clean water to soften it. Use kitchen paper to lift out colour to reinstate the highlights.

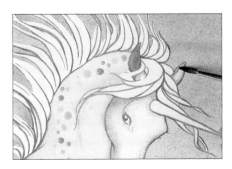
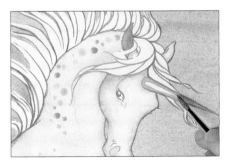
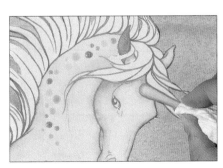

12 Make a darker mix for the inside of the ear on the left. Paint the other ear with a lighter, yellower mix.

13 Go round the outline of the unicorn's horn with a rich orange mix of the two colours.

14 Brush clean water on to the inside of the horn and use kitchen paper to dab back the colour to almost white.

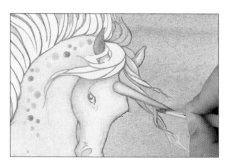 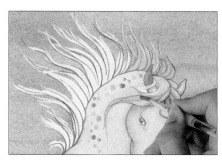 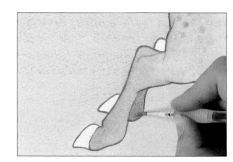

15 Use a redder, stronger mix and a no. 2 brush to paint the forelock.

16 Continue painting the mane.

17 Mix yellow ochre with cadmium yellow and cadmium red to paint the back leg that is in shadow from the other leg.

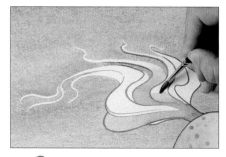 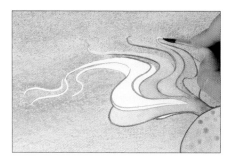 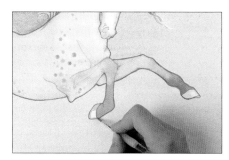

18 Use the no. 4 brush to paint the tail with a cadmium red and cadmium yellow mix, which should be darker towards the base of the tail.

19 Use a lighter, yellow mix towards the end of each tendril of the tail.

20 Mix Winsor yellow and cadmium yellow and paint the hooves with a no. 2 brush, leaving lighter areas for highlights.

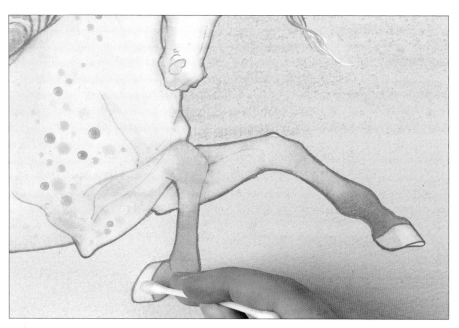

21 Soften and blend the paint on the hooves using a cotton bud and clean water.

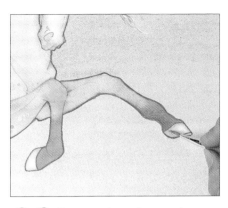

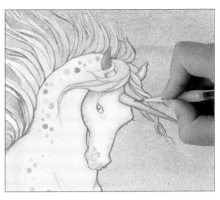

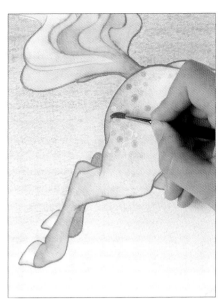

22 Deepen the yellow at the edges of the hooves to make them look more three-dimensional.

23 Wash Winsor yellow and cadmium yellow over the unicorn's horn, wet on dry.

24 Use the no. 4 brush and cadmium yellow and cadmium red to add warm orange shading to the legs and rump.

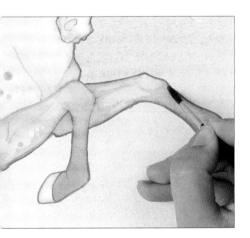

25 Continue adding shading to the front legs.

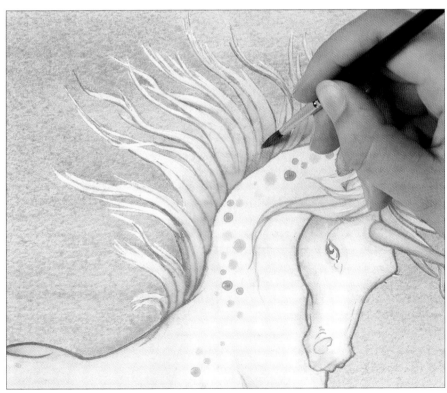

26 Darken the base of the mane with the same shading mix. Apply the paint and then blend it in to soften the edges with clean water.

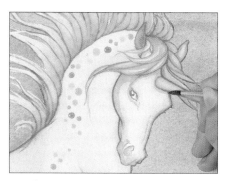

27 Sculpt the face with the same deep orange. Soften any hard lines with clean water.

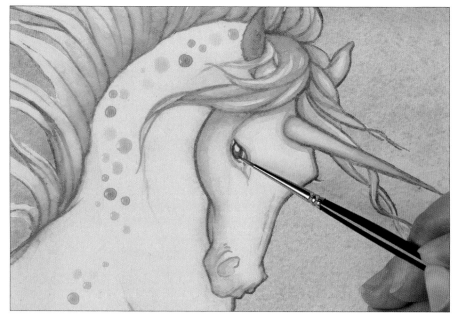

28 Paint the unicorn's eye with cerulean blue and a no. 00 brush.

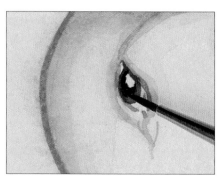

29 Paint the pupil using burnt umber and the no. 00 brush.

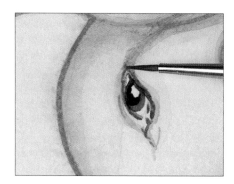

30 Use a mix of burnt sienna and cadmium red to define the outline of the eye.

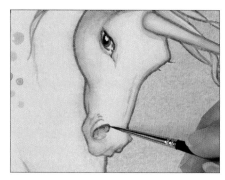

31 Define the nostril using the same mix.

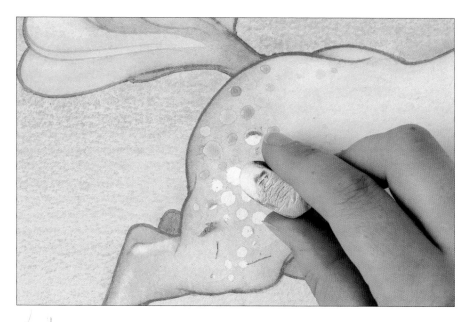

32 Rub off the masking fluid dapples using an eraser or clean fingers.

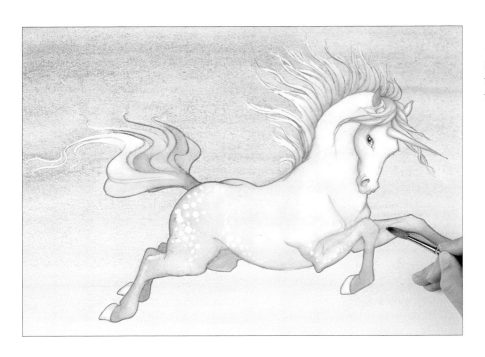

33 Mix Winsor yellow and cadmium yellow and use the no. 8 brush to paint a thin wash over the face, back, legs, crest and chest of the unicorn.

The finished unicorn. After completing the main part of the painting I redefined the outlines using a strong mix of cadmium red and burnt sienna. It is helpful to vary the weight of the line, producing both thin and thick lines to give the illusion of three dimensions to the unicorn's form.

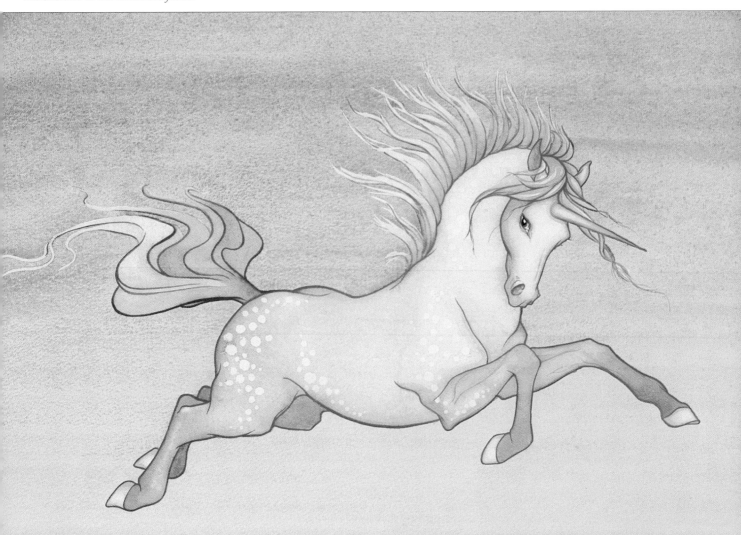

Enchanted Glade

At dusk, a spell is woven, for in this enchanted glade sleeps a unicorn. An almost dreamlike quality is achieved by using pale tones and a limited range of warm colours. In this project, the unicorn and the background are as important as each other. The balanced composition enhances the restful, harmonious quality found in this artwork. Intricate flower forms fill the foreground, interweaving with the unicorn's tail, while overhead two trees gently lean towards the centre of the composition, creating an enclosed canopy and secluded resting place for the unicorn. In the far distance, woodland can be seen through the settling mist.

YOU WILL NEED

H pencil

300gsm (140lb) rough watercolour paper, 59.5 x 42.5cm (23½ x 16¾in)

Masking fluid and old paintbrush

Eraser

Kitchen paper

Paints: burnt sienna, cadmium red, Naples yellow, olive green, permanent sap green, burnt umber, cadmium yellow, rose madder, raw sienna, yellow ochre, cobalt blue, Winsor violet, viridian, permanent rose

Brushes: 19mm (¾in) flat and numbers 0, 4, 8 and 10 round

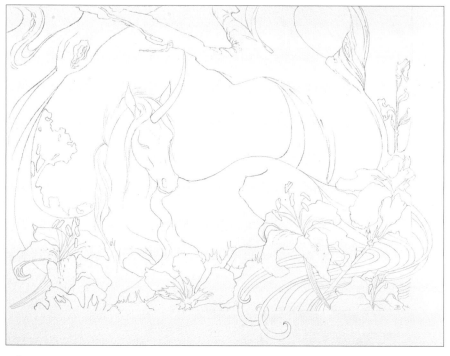

1 Draw the scene using an H pencil.

2 Use masking fluid and an old brush to mask out the unicorn and the lilies.

3 Wet the whole paper with clean water. Mix burnt sienna, cadmium red and Naples yellow and apply the wash from the top of the paper using the 19mm (¾in) flat brush. Add more yellow to the mix lower down the paper.

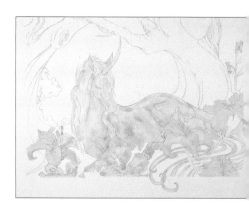

4 While the first wash is wet, paint a mix of olive green and permanent sap green up from the bottom.

5 Mix burnt umber and burnt sienna for the left-hand tree. Once the background wash is dry, use the no. 10 brush to paint on the tree wash. Your brush strokes should follow the contours of the tree.

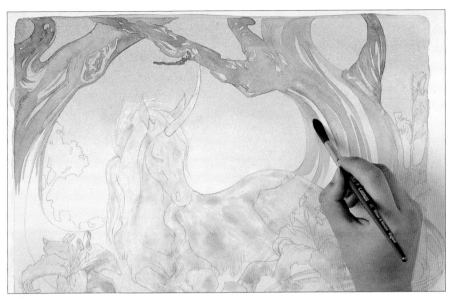

6 Paint the right-hand tree in the same way. The wash should become weaker lower down the tree.

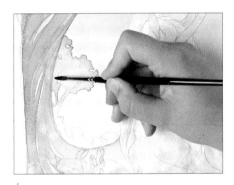

7 Mix a light wash of cadmium red, burnt sienna and cadmium yellow and use the no. 4 brush to paint the background trees. Start at the edges and allow the mix to get lighter in the middle.

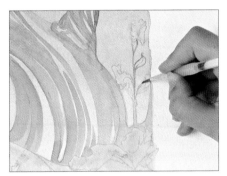

8 Use the no. 2 brush to paint the leaves and stalk of the plant on the far right with a mix of permanent sap green and olive green.

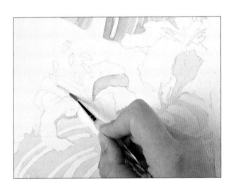

9 Remove the masking fluid with an eraser or clean fingers. You may need to redraw some of the pencil lines. Mix rose madder and Naples yellow and use a no. 2 brush to paint the undersides of the lily's petals.

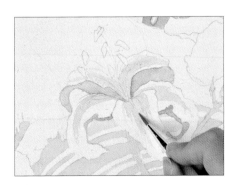

10 Paint the centre of each petal with a paler, pinker wash of rose madder with a tiny bit of Naples yellow.

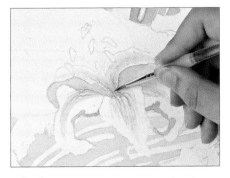

11 Use rose madder to paint the lines on the lily petal, using the end of a no. 2 brush and painting wet on dry.

TIP

Watercolour paint dries quickly when you are painting precise details like these, so most of these steps are done using the wet on dry technique.

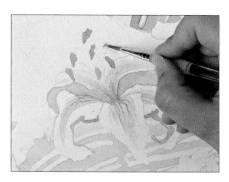

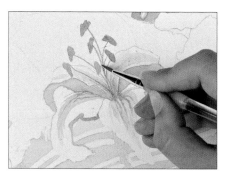

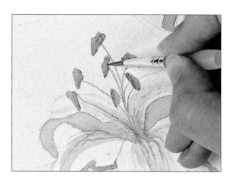

12 Mix raw sienna and Naples yellow and paint the anthers covered in pollen.

13 Use a mix of olive green and permanent sap green to paint the stamens.

14 Paint shadows on the anthers to give them form, using a mix of burnt sienna and yellow ochre.

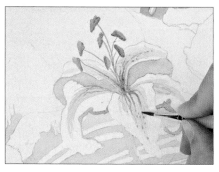

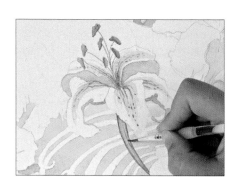

15 Add dots of rose madder to the lily petals.

16 Outline the stem with downwards strokes of permanent sap green and olive green. Fill it in with a lighter wash of the same mix.

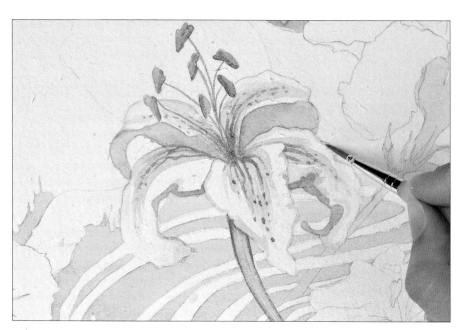

17 Make a very thin wash of cobalt blue with a little Winsor violet and add shadow to the edges of the lily petals to define them.

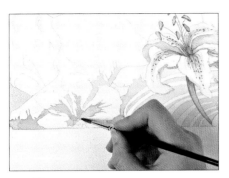

18 Mix Naples yellow with rose madder and use the no. 4 brush to paint the centres of the other flowers. Start with the one in the middle of the foreground.

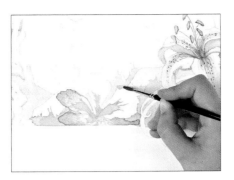

19 Paint the outsides of the petals in a pinker mix of the same two colours. Start painting from the edges of the petals so that the paint is lighter towards the yellow centre.

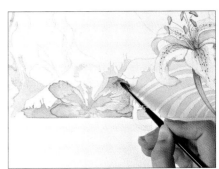

20 Drop in more rose madder at the edges of the petal, wet into wet.

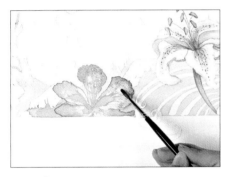

21 Wash the no. 4 brush and drop a little clean water into the inner part of the pink petals.

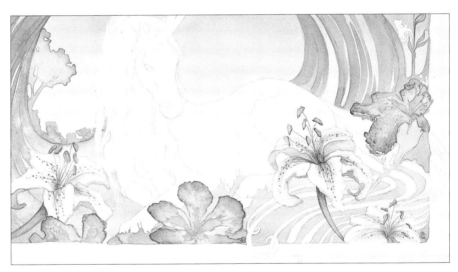

22 Paint the other two flowers in the same way.

23 Paint a light wash of viridian and sap green over the whole stalk area of the flower on the far right, leaving some areas pale for highlights. Drop in a stronger mix of the same green wet into wet around the edges.

24 When the paint is dry, change to the no. 0 brush and add fine details to the stalk using the stronger green mix.

25 Use a thin mix of Winsor violet to add shadow to the sepals and stalk, working wet into wet.

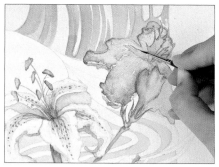

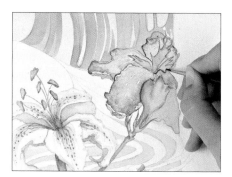

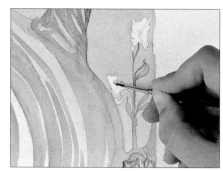

26 Outline the edges of the yellow centre of the flower using the no. 0 brush and a mix of burnt sienna, Naples yellow and rose madder.

27 Use the same mix and brush to define each petal. The line does not need to be even; it will look more natural if it varies in strength.

28 Make a very weak mix of cobalt blue and Winsor violet and use the no. 0 brush to paint the white flowers at the top right. Outline them first, then soften the lines with clean water.

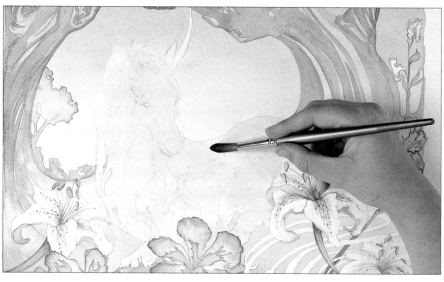

30 Lift out areas of paint using kitchen paper to suggest highlights.

29 Now begin painting the unicorn. Wet the area first with clean water. Then make a weak mix of burnt sienna and permanent rose and use the no. 10 brush to wash it over the whole unicorn.

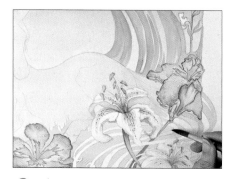

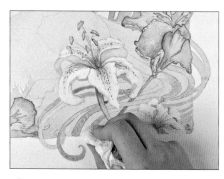

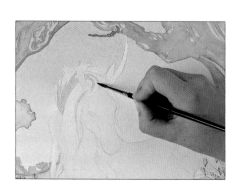

31 Use the same mix and the no. 8 brush to paint the tendrils of the unicorn's tail. Take care not to paint over other elements.

32 The paint should be darker towards the ends of the tendrils. Take back the strength of the mix in places by lifting out paint with kitchen paper.

33 Paint the mane and forelock using a mix of burnt umber and permanent rose and the no. 4 brush. Put in the mid tones and leave the lighter paint underneath for highlights.

44

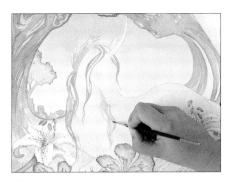

34 Change to the no. 0 brush and continue adding darker details to the unicorn's mane, forelock and beard.

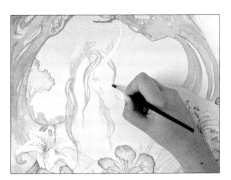

35 Paint the insides of the ears with the no. 4 brush. Outline the face, painting on the pencil lines.

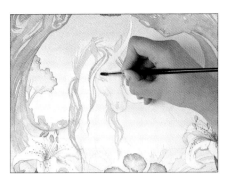

36 Continue painting other facial details. Soften any hard lines using a damp brush.

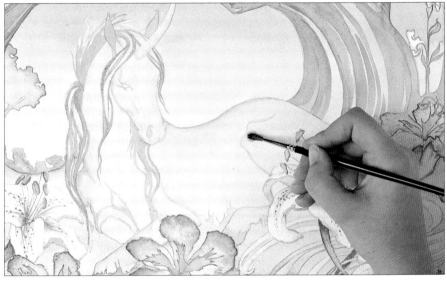

37 Paint in the outlines of the whole unicorn over the pencil marks, and blend in the lines with clean water.

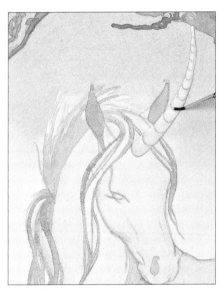

38 Redraw the pencil lines for the unicorn's horn. Then outline the horn and ridges using the no. 0 brush and blending in the lines with clean water.

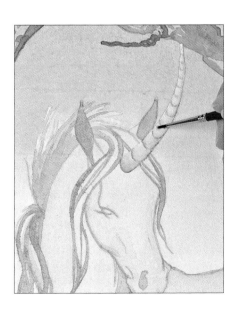

39 Drop in more colour wet into wet to shade the underside of the horn.

40 Use a darker mix of burnt umber and permanent rose and the no. 0 brush to add detail to the ears and mane.

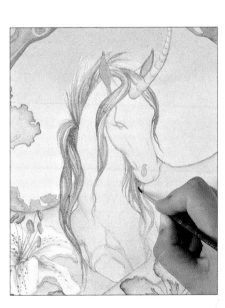

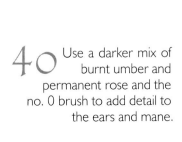

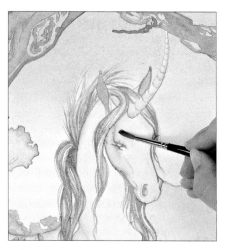

41 Use the no. 4 brush and the same mix to add detail to the face. Blend it in with clean water to create shading.

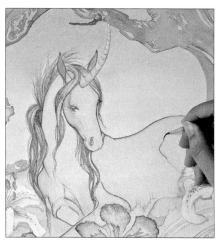

42 Add more burnt sienna to the mix and go over the main lines of the unicorn again using the no. 0 brush.

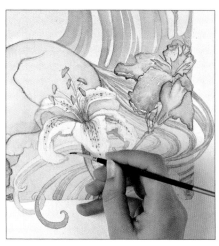

43 Use the same brush and mix to add texture to the tail.

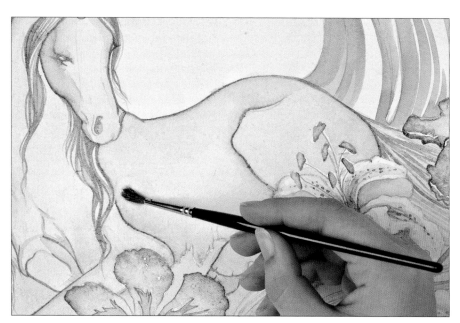

44 Use a weaker mix and the no. 4 brush to shade round the haunches, under the belly and the shoulder. Blend in the paint using a wet brush.

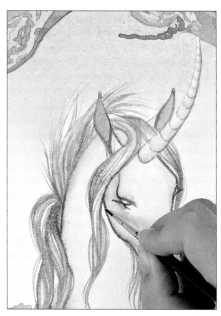

45 Strengthen the line round the unicorn's face by painting it with the no. 0 brush and burnt umber.

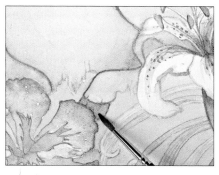

46 Paint the hind hoof with a mix of burnt sienna and permanent rose and the no. 4 brush.

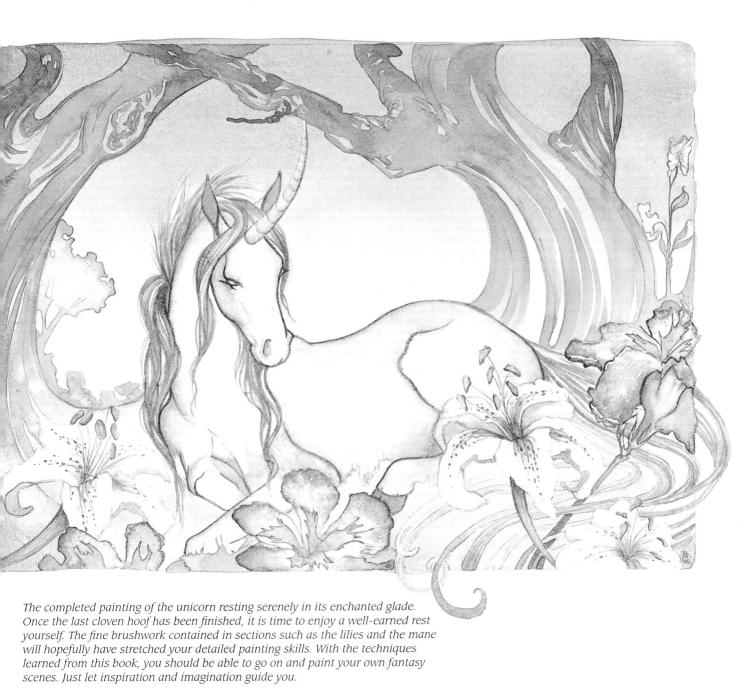

The completed painting of the unicorn resting serenely in its enchanted glade. Once the last cloven hoof has been finished, it is time to enjoy a well-earned rest yourself. The fine brushwork contained in sections such as the lilies and the mane will hopefully have stretched your detailed painting skills. With the techniques learned from this book, you should be able to go on and paint your own fantasy scenes. Just let inspiration and imagination guide you.

Index

For a complete list of all our books, see www.searchpress.com

- A huge selection of art and craft books, available from all good book shops and art and craft suppliers

- Clear instructions, many in step-by-step format

- All projects are tried and tested

- Full colour throughout

- Perfect for the enthusiast and the specialist alike

- Free colour catalogue

- Friendly, fast, efficient service

- Customers come back to us again and again

For the latest information on our books, or to order a free catalogue, visit our website:

www.searchpress.com

Alternatively, write to us:

SEARCH PRESS LTD,
Wellwood, North Farm Road,
Tunbridge Wells, Kent,
TN2 3DR

Tel: (01892) 510850
Fax: (01892) 515903
E-mail: sales@searchpress.com

Or if resident in the USA to:

SEARCH PRESS USA,
1338 Ross Street,
Petaluma, CA 94954

Tel: (707) 762 3362
24-hour fax:
(707) 762 0335
E-mail:
sales@searchpressusa.com
www.searchpressusa.com

Or if resident in Australia to:

SEARCH PRESS AUSTRALIA,
A division of Keith Ainsworth
Pty Ltd,
Unit 6, 88 Batt Street, Penrith,
2750, NSW

Tel: 047 32 3411
Fax: 047 21 8259
E-mail:
sales@searchpress.com.au
www.gurooz.com.au